1 Page AT A TIME

A DAILY creative COMPANION

ADAM J. KURTZ
(STILL JUST SOME GUY)

A TarcherPerigee Book

tarcherperigee

AN IMPRINT OF PENGUIN RANDOM HOUSE LLC
375 HUDSON STREET
NEW YORK, NEW YORK 10014

COPYRIGHT © 2014 BY ADAM J. KURTZ

Most TarcherPerigee books are available at special quantity discounts for bulk purchase for sales promotions, premiums, fund-raising, and educational needs. Special books or book excerpts also can be created to fit specific needs. For details, write: SpecialMarkets@penguinrandomhouse.com.

ISBN: 978-0-14-312987-5

First edition: October 2014

Printed in the United States of America

5 7 9 10 8 6

IN MEMORY OF
Blanche Davids Gewirtz
WHO TAUGHT ME TO:

1. *never* BE AFRAID TO ASK
2. HAVE A *little* SUGAR
3. APPRECIATE LIFE'S *surprises*
4. DOCUMENT *everything*

"I LOVE YOU, A BUSHEL & A PECK"

THIS COULD BE
anything:

- ☐ A JOURNAL
- ☐ A KEEPSAKE
- ☐ A CALENDAR
- ☐ A FRIEND
- ☐ ALL OF THE ABOVE

this

is

just

paper

THE *rest* IS
UP TO

YOU!

(WITH A LITTLE HELP)

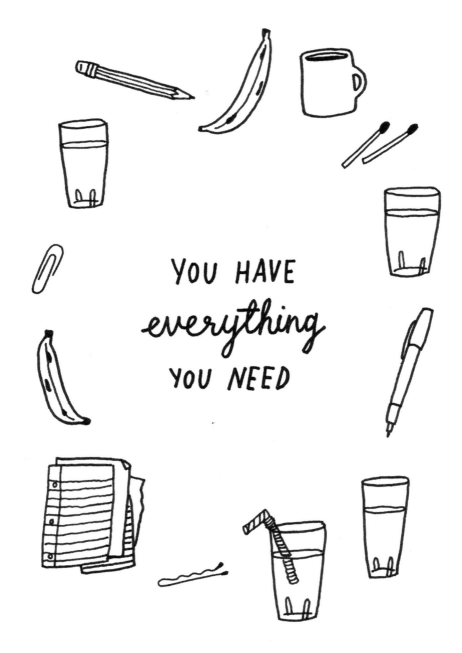

WHAT ARE YOUR GOALS FOR
THE NEXT YEAR? WRITE BELOW.

PEOPLE I CAN ALWAYS CALL

Chase
BEST FRIEND

Me
HAS A CAR

Mom
A PARENT

V
ALWAYS READY TO PARTY

Chase
COOL SIBLING

uncle Bob
KNOWS EVERYTHING

Erika
LESS COOL SIBLING

Dad
KNOWS JUST ENOUGH

Aunt Lisa
FAVORITE AUNT

Mee-maw
GRANDPARENT

Kyle
OWES ME A FAVOR

cassidy
1 MORE

SELECT THE FEELINGS
THAT RESONATE MOST

- ☒ WOW I AM SO HAPPY TO BE ALIVE
- ☒ I JUST NEED TO KEEP AT IT
- ☒ ANYTHING IS POSSIBLE
- ☐ LOVE IS STUPID (BUT CAN I PLS)
- ☒ I AM AFRAID OF DEATH, BUT APPRECIATE THAT IT IS INEVITABLE
- ☐ I CARE ABOUT OTHERS MORE THAN MYSELF
- ☐ THE INTERNET IS OVERWHELMING, BUT I CAN'T STOP
- ☐ BE THE CHANGE YOU WANT TO... WHATEVER
- ☒ PEOPLE CAN CHANGE (THEMSELVES), EVEN ME
- ☐ IF I CAN MAKE IT THROUGH THIS, I CAN MAKE IT THROUGH ANYTHING
- ☐ I HAVE MY "1 THING" THAT WILL ALWAYS KEEP ME GOING
- ☐ WOW THIS BOOK IS KIND OF INTENSE

WHAT TIME IS IT?

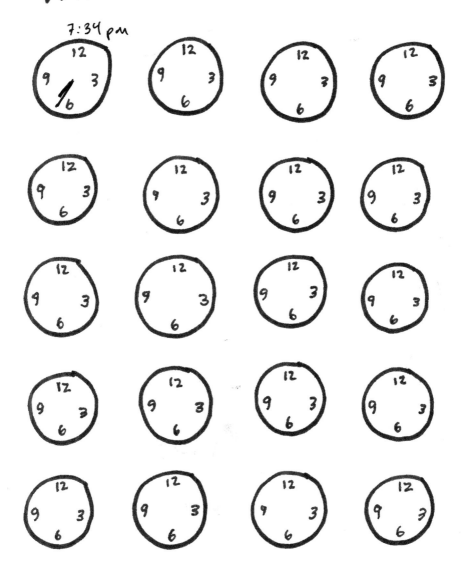

*
Some pages are just about you, no prompt, no jokes.
Don't be afraid! Don't even think, just write or draw, just let it happen!

LEARN TO DRAW

STEP 1.
DRAW TWO SQUARES BELOW

CONGRATULATIONS, YOU DID IT!

GO OUT OF YOUR WAY TO DO SOMETHING
YOU'VE NEVER DONE BEFORE.

put a scrunchy in my
hair
its currently in
Chase's large purple velvet
scrunchy

CHASE
CHAPMAN

chase@trycrypto.com TRYCRYPTO

Chase!

 * IF AT FIRST YOU DON'T SUCCEED, THAT'S OK. IF YOU NEVER SUCCEED, I DON'T KNOW WHAT TO TELL YOU, HONESTLY.

DESCRIBE A CHILDHOOD BIRTHDAY

FREE SPACE

WHAT ARE YOU UP TO?
SHARE THIS PAGE WITH #JK1PAGE
SO WE CAN TAKE A LOOK!

WHAT'S YOUR NAME?
WHY WERE YOU NAMED
 THIS & WHO DECIDED?
WHAT DOES IT MEAN?
WHAT ABOUT NICKNAMES?

WHAT ARE YOU SEARCHING FOR?

SEARCH

I'M FEELIN LUCKY

If you find numbers overwhelming, a grid can help. Space them out and add them up! It's not so bad if you just think about it differently. Draw your first grid here. ✳

THINK OF SOMETHING
YOU'RE INSECURE ABOUT,
THEN WRITE IT HUGE.
FILL THE ENTIRE SPACE!
STARE AT IT. NOW TURN
THE PAGE.

WHERE DO YOU THINK YOU'LL BE IN 5 YEARS?
ARE YOU "ON TRACK" OR NOT? ARE YOU
FAIRLY SURE OR GUESSING? IS THIS QUESTION
JUST REALLY SCARY & AWFUL?

COPY THE LINE 20 TIMES,
OR UNTIL YOU LEARN YOUR LESSON!

I CAN DO ANYTHING

DESCRIBE SOMETHING YOU SAW ON THE GROUND TODAY

(WHERE WAS IT? WHO PUT IT THERE?)

SEND A TEXT TO THAT NEW
PERSON YOU MET LAST NIGHT.
(DON'T BE NERVOUS!)

GO OFF
THE GRID!

FILL OUT YOUR SICK DAY CHECKLIST:

- ☐ LOTS OF DRINKS
- ☐ TISSUES
- ☐ VITAMIN C
- ☐ A LITTLE SYMPATHY
- ☐
- ☐
- ☐
- ☐
- ☐
- ☐
- ☐
- ☐

DEAR MOM,

WRITE A LETTER TO YOUR MOM

WRITE YOURSELF A
SECRET MOTIVATION,
THEN FOLD THIS
PAGE UP TIGHT!

✱ Hmm, that last folded page looks pretty interesting... QUICK, FILL THIS WITH A DISTRACTION!

DESCRIBE YOURSELF IN
15 WORDS, AS A
SENTENCE OR A LIST.

EVERYTHING THAT
WENT WRONG TODAY:

NEVER FORGET:
YOU'RE LITERALLY A
GIANT TOOL. LAUGH ABOUT
BEING A TOOL & REMEMBER
THAT EVERYONE ELSE
IS 1 TOO.

CARE PACKAGE

FILL THIS BOX WITH LOTS OF GOOD STUFF!

1
BANANA

✱ You know what else would be good? An "I don't care" package... 1 big box full of "LEAVE ME ALONE."

RETURN TO
SENDER

GET POSTAL ADDRESSES FOR
3 FAR-AWAY FRIENDS &
WRITE THEM POSTCARDS
THIS YEAR. COME BACK TO
CHECK THEM OFF WHEN YOU DO!

DESCRIBE HOW YOU
MET YOUR BEST FRIEND

TAPE A RESTAURANT
CHECK TO THIS PAGE
& DESCRIBE YOUR MEAL

WHAT I REALLY WANTED TO SAY:

...and now, *WHAT I REALLY REALLY WANTED TO SAY BUT DIDN'T EVEN WANT TO WRITE DOWN BUT NOW MY BOOK IS MAKING ME DO IT SO HERE GOES NOTHING:* ✳

WHAT WAS THE MOST CHALLENGING
THING YOU DEALT WITH LAST YEAR?

THIS IS YOUR SPACE

CREATE YOUR OWN CONVERSATION HEARTS!

KEEP GOING!

COVER THIS PAGE ˣ
IN POP-UP ADS!

IT'S JUST

PAPER!

QUIETLY DO GOOD FOR OTHERS.
GIVE TO SOMEONE ON THE STREET,
LEAVE AN EXTRA-LARGE TIP.
DON'T TELL ANYONE. NO EGO BOOST.
JUST NOTE THE DATE BELOW.

THERE IS NO EXCUSE, BUT

✱ Draw a grid, then fill boxes with big X marks to make your own cross-stitch pattern.

WHAT IS YOUR GREATEST
WISH FOR THE FUTURE?

HEY ARE YOU AWAKE? I JUST WANTED TO SAY THANKS.

WHAT YOU SAID REALLY MEANT A LOT TO ME.

TTYL.

TAKE A MOMENT TO
OBSERVE SOMETHING
SMALL TODAY. WHAT
DID YOU SEE?

MAKE A PLAYLIST FOR A BIRTHDAY PARTY:

1. THE GRATES
 "19 20 20"

2.

3.

4.

5.

6.

7.

8.

WAIT, DON'T POST THAT! WRITE YOUR ANGRY STATUS UPDATE BELOW, THEN 📷 SHARE A PHOTO... IF YOU EVEN WANT TO ANYMORE.

ARE WE THERE YET?

☐ NO ☐ NO ☐ NO

☐ NO ☐ NO ☐ NO

☐ NO ☐ NO ☐ NO

☐ NO ☐ NO ☐ NO

☐ NO ☐ NO ☐ NO

☐ NO ☐ NO ☐ NO

☐ NO ☐ NO ☐ NO

☐ NO ☐ NO ☐ NO

☐ NO ☐ NO ☐ YES

*treat yourself to a nap!

✳ UGH, FIVE MORE MINUTES PLEASE! Why am I always even grumpier after a nap?

♡ I LIKED THIS

♡ I LIKED THIS

♡ I LIKED THIS ♡ I LIKED THIS

♡ I LIKED THIS ♡ I LIKED THIS

♡ I LIKED THIS ♡ I LIKED THIS

TAKE A DEEP BREATH
& COUNT TO 10, REPEAT

~~IIII~~ ~~IIII~~

Breathing seems so obvious, but don't you feel better after all those deep breaths? Take one more, really inhale deeply through your nose, and feel your chest rise. Hold it for a few seconds, then let it out super slowly. O-K, let's keep going.

YOU CAN DO IT!
(DEPENDING ON
WHAT IT IS)

DRAW YOURSELF AN
IDENTIFICATION CARD.
WHAT'S ON IT? WHAT
MATTERS?

AGE? HEIGHT?
ARE YOU SMILING FOR
THE PHOTO OR NOT?

DREAM JOBS:

~~NAP TAKER~~ ~~CANDY EATER~~

IT'S JUST PAPER!
CAREFULLY CUT THIS
PAGE INTO A SINGLE
LONG RIBBON. OR DON'T!

CONNECT THE DOTS
IN ANY ORDER:

WHAT DO YOU SEE?

HOLD ON, GOTTA TWEET THIS

📷 📍

140 TWEET

LIST 5 FRIENDS YOU THINK YOU'LL HAVE FOREVER:

1 _____

2 _____

3 _____

4 _____

5 _____

TAPE A BUS, TRAIN,
OR PLANE TICKET
TO THIS PAGE:

(WHERE ARE YOU GOING? WHY?)

TTYLAIRLINES

JFK → PDX

HOW I AM FEELING

- ☐ EVERYTHING SUCKS
- ☐ SOME THINGS SUCK
- ☐ SOMETIMES I SUCK
- ☐ SOMETIMES EVERYONE ELSE SUCKS
- ☐ NOTHING EVER SUCKS!
- ☐ EVERYTHING SUCKS SOMETIMES
- ☐ SUCK IT

WRITE A SECRET
IN THE DARK!

HEY!
WHAT
ARE YOU
UP TO
TODAY?

COMPLETE THIS STATEMENT UNTIL
THE PAGE IS FULL:

IF I CAN DO _____, I CAN DO ANYTHING.

ENJOY THE UNKNOWN

TAPE A SMALL
PHOTO OR IMAGE
HERE, THEN TRY
TO COPY IT BELOW!

WHEN LIFE CLOSES A DOOR,
IT OPENS A WINDOW. BUT
IF THE DOOR ISN'T LOCKED,
THERE'S NO REASON YOU
CAN'T JUST OPEN IT FOR
YOURSELF, RIGHT?

http:// WHERE ARE YOU GOING? GO

WRITE IT HUGE

These big pages are the best! You can't always scream in public but you can definitely shout in here. ✳

✳ Draw yourself a grid. Can you fit a tiny word in each box? Can you write a story that fits perfectly?

DRAW YOUR DREAM HOUSE
(OR APARTMENT! OR CASTLE!)

IT'S JUST PAPER!
DRAW SOME SALT, THEN
THROW IT OVER YOUR
SHOULDER FOR LUCK.

PAUSE AT AN OVERPASS
& COUNT THE CARS ZOOMING
BELOW. HOW DOES IT FEEL?

MAKE A PLAYLIST TO GO FOR A RUN:

1. WEEKENDS
 "RAINGIRLS"

2.

3.

4.

5.

6.

7.

8.

TRAVEL PLANS: WHAT LANDMARK DO YOU MOST WANT TO SEE?

SNACKS TO EAT

- ☐ PRETZELS
- ☐ ICE CREAM
- ☐ DONUT
- ☐ ANOTHER DONUT
- ☐ LICORICE
- ☐ CANDY BAR
- ☐ CHIPS
- ☐ CHIPS & DIP
- ☐ ~~CARROT STICKS~~
- ☐ BIRTHDAY CAKE
- ☐ JELLY BEANS
- ☐ 3 COOKIES
- ☐ 1 MORE DONUT
- ☐ GUMMY WORMS

PRESERVE SOME FEELINGS IN THE JARS.
DRAW SOME MORE JARS. YOU'LL BE ABLE
TO ENJOY THEM IN COLDER MONTHS!

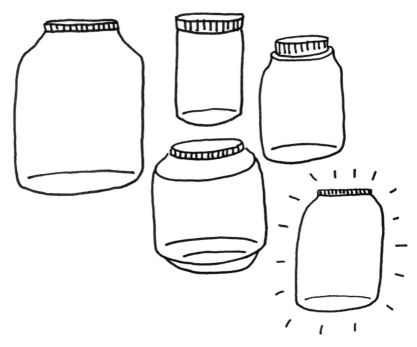

WRITE A PEP TALK FOR A BAD DAY.
(WHAT DO YOU DO WHEN LIFE GIVES YOU LEMONS?)

DO YOU BELIEVE IN SOULMATES?
IS YOURS OUT THERE? DO WE GET
MULTIPLE OPTIONS? WRITE A
NOTE TO YOURS, WHEREVER THEY ARE!

WRITE DOWN EVERYTHING
THAT'S BOTHERING YOU,
THEN JUST TURN THE PAGE

QUARTERLY CHECK-IN

THINK ABOUT THE LAST 3 MONTHS
& RANK YOURSELF ON THE SMILEY SCALE.

LET'S
FACE IT > ☺ GOOD 😐 FAIR ☹ POOR

GENERAL OUTLOOK ○	PERSONAL GROWTH ○	PHYSICAL HEALTH ○
PLANNING AHEAD ○	TAKING CARE ○	EATING WELL ○
SLEEPING HABITS ○	BEING AWESOME ○	MENTAL HEALTH ○
SOME DAILY CREATIVITY ○	SHOWING KINDNESS ○	CALLING HOME ○
WORKING HARD ○	HAVING FUN ○	BEING A FRIEND ○
STAYING CALM ○	TRYING HARD ○	ENJOYING YOUR SPACE ○
EARNING A LIVING ○	GOING OUTDOORS ○	THAT 1 THING ○
FEELING CONTENT ○	FUNNY TWEETS ○	FIGURING IT OUT ○

SIT DOWN IN THE
SHOWER. THAT'S IT.

ANONYMOUS ASKED YOU:

I HATE YOU YOUR UGLY JK YOU R
SO CUTE WATS UR BEAUTY SECRET

xo

FUTURE PET NAMES:

* NO MATTER WHAT, THERE
WILL ALWAYS BE PIZZA.

WRITE AN INSPIRATIONAL QUOTE BELOW,
THEN SHARE IT ONLINE WITH YOUR FRIENDS!

DRAW A LAYER CAKE
& DESCRIBE EACH LAYER

That's a huge cake! Maybe we should draw a salad next, or at least a celery stick or something.

GIVE THIS PAGE TO A FRIEND

WRITE THAT THING YOU
PROMISED NOT TO JOKE
ABOUT ANYMORE THAT IS
STILL TOTALLY FUNNY.

TAPE A $5 BILL

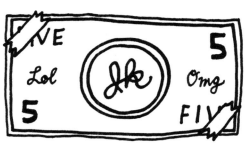

TO THIS PAGE &
FORGET ABOUT IT!

WRITE A LETTER TO YOURSELF
SIX MONTHS FROM NOW

Cool, now write a letter to yourself three minutes from now!

LIST EVERYTHING YOU CAN
REMEMBER BEING AFRAID OF,
THEN CROSS OUT STUFF YOU'VE
GOTTEN OVER!

SPIDERS
~~TEENAGERS~~
~~THE DARK~~
MUMMIES

THERE IS NOTHING IN YOUR WAY

WEAR SOMETHING
INSIDE-OUT TODAY,
& TELL ME HOW
 IT WENT:

DRAW YOUR VIRAL HIT ✗

0:20/4:33

I didn't want to say anything but you've been pressing really hard with that pen. Can you just chill out please? ✳

WRITE IT HUGE

FILL ALL OF THIS SPACE.
STARE AT IT.
NOW TURN THE PAGE.

IS HAPPINESS EVEN A PLACE?
DO YOU EVER JUST "GET THERE,"
OR IS IT MORE AN OUTLOOK ON
LIFE & ITS PROGRESS?

JUST WRITE YOUR NAME.
JUST BE HERE RIGHT NOW.
THAT'S IT.

TAKE YOURSELF FOR A
COFFEE OR TEA.
SIT OUTSIDE. DESCRIBE
3 PEOPLE YOU SAW.

WATER YOU

WAITING FOR?

SEEMS LIKE
✳ NOBODY NOTICED,
DON'T WORRY
ABOUT IT!

TO-DO LIST:

- ☐ MAKE A LIST
- ☐ CHECK FIRST 2 BOXES

treat yourself to *a movie!*

STAND IN PLACE FOR 1 MINUTE.
CLOSE YOUR EYES & BREATHE IN
& OUT VERY SLOWLY. FOCUS ON
THE SIZE OF YOUR BODY IN RELATION
TO THE SPACE. NO, LIKE OUTER
SPACE. MEOW LIKE A DOG. ARF!
POPCORN. HORSESHOE. WHAT'S
HAPPENING RIGHT NOW? OKAY,
NOW OPEN YOUR EYES.

DRAW BANANAS FOR 20 MINUTES,
THEN SPLIT!

TAPE A PAGE FROM ANOTHER BOOK
OR NOTEBOOK TO THIS PAGE
(I GET LONELY SOMETIMES)

GO TO BED

I'LL BE HERE
TO MORROW

YOU'RE A STAR! PROBABLY.
WHAT WOULD A FILM OF
YOUR LIFE BE CALLED?
WHO WOULD PLAY YOU?
DRAW A POSTER FOR IT!

EIGHT BEST PIZZA SLICES

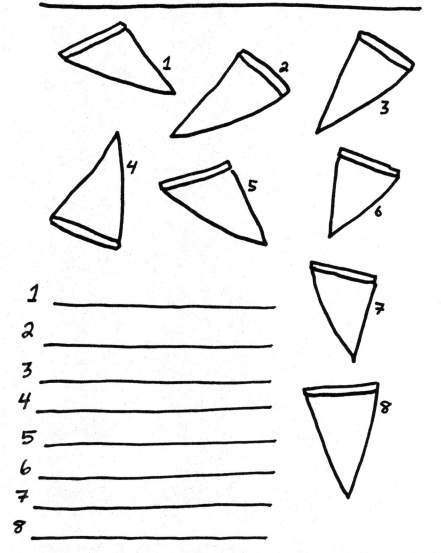

1 _____
2 _____
3 _____
4 _____
5 _____
6 _____
7 _____
8 _____

WHAT ARE SOME THINGS YOU CAN BUY FOR $1?

WHAT ARE SOME THINGS
YOU CAN'T BUY AT ALL?

DRAW A LADDER
(WATCH YOUR STEP)

GIVE THIS PAGE TO A FRIEND

WRITE A NOTE TO
YOUR FUTURE SELVES.

WHAT DID YOU WANT TO
BE "WHEN YOU GREW UP?"
HOW DO YOU FEEL NOW?

NEW MESSAGE ▬

TO: YOU
CC: EVERYONE ELSE
BCC: ME

SUBJECT:

WRITE AN EMAIL TO ANYONE
WHO EVER DOUBTED YOU...
INCLUDING YOURSELF!

Have you ever written an email and then just saved it without sending? Sometimes just writing is all you need. Use this page to get something down on paper that you just need to take out of your brain. ✳

HEY,

WHAT ARE
WE
DOING

TONIGHT?

TAPE SOMETHING SHINY
TO THIS PAGE. WHAT
IS IT FROM?

MAKE SPACE FOR YOURSELF

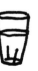

YOU COULD DO THIS
WITH YOUR
EYES CLOSED!

RT AFTER ME:
I CAN DO ANYTHING

#JK1PAGE

 110 TWEET

GIVE THIS PAGE TO A FRIEND

DON'T DO ANYTHING.
SIT & TALK FOR HOURS.
THIS IS THE BEST PART
OF BEING FRIENDS.

Draw a grid. Or do whatever you want! Embrace the structure or fight the system. Make your own rules! YEAHHH! ✳

EVERY ROMANTIC RELATIONSHIP
TEACHES US ABOUT SOMETHING WE
WANT OR NEED IN A PARTNER.
WHAT HAVE YOU LEARNED SO FAR?

Shhh...
DRAW AN ODDLY-SPECIFIC
"DO NOT DISTURB" SIGN

SIT IN ONE PLACE FOR
TEN MINUTES & DRAW
WHAT YOU OBSERVE.

MAKE A PLAYLIST
FOR GETTING EVEN:

1. MICHELLE BRANCH
 "ARE YOU HAPPY NOW?"

2.

3.

4.

5.

6.

7.

8.

TRAVEL
PLANS: | PLAN A WEEKEND
GETAWAY (& GO!)

INTERNET TO-DO LIST

- ☐ CHECK EMAIL
- ☐ CHECK NOTIFICATIONS
- ☐ UPDATE STATUS
- ☐ SEARCH NEWS ITEM
- ☐ TWEET
- ☐ READ FAVORITE BLOG
- ☐ CHECK EMAIL
- ☐ BROWSE ONLINE SHOP
- ☐ READ FRIEND'S BLOG
- ☐ UPDATE STATUS ABOUT IT
- ☐ SEARCH FOR YOURSELF
- ☐ PLAY A GAME
- ☐ WATCH A VIDEO
- ☐ TWICE
- ☐ OMG
- ☐ CHECK EMAIL AGAIN
- ☐ CHAT YOUR MOM
- ☐ SIGN OFF
- ☐ PULL OUT PHONE

*treat *yourself *to *a day *off!*

*
HELLO? IS ANYONE THERE? WORDS? DOODLES? WHERE ARE YOU GUYS? HELLO? WHAT IS HAPPENING TO ME?!

WHO IS THE 1 PERSON
YOU CAN ALWAYS COUNT
ON? WRITE DOWN THEIR
PHONE NUMBER. ADDRESS.
EMAIL. BIRTHDAY. DO NOT
LET THIS PERSON GO.
TELL THEM WHAT THEY
MEAN TO YOU.

IT'S JUST PAPER!
TEAR THIS PAGE IN
 HALF.

You're tearing this one in half, right? *

THINGS MIGHT NOT BE OK
TODAY OR TOMORROW, BUT
WE'LL MAKE IT, 1 PAGE AT
A TIME, SO HANG IN THERE!

CLICK TO CONTINUE

www.myself.com

ABOUT ME:

WHO I'D LIKE TO MEET:

📷 SHARE #JK1PAGE

10 THINGS I AM REALLY GOOD AT:

1. MAKING LISTS
2.
3.
4.
5.
6.
7.
8.
9.
10.

*DON'T FORGET THAT TOMORROW IS LITERALLY JUST 1 DAY AWAY.

WRITE SOME <u>TERRIBLE</u>
ADVICE, THEN PRACTICE
IGNORING IT.

Have you noticed that I have like a massive sweet tooth? Do you have any candy? ✳

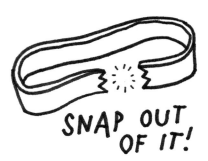

SNAP OUT
OF IT!

WRITE IT HUGE

WHAT ARE YOU EXCITED FOR?

THIS BOOK ⇄ 32 PAGES AGO

DRAW A LADDER
(WATCH YOUR STEP)

TAPE A PARAGRAPH FROM
A NEWSPAPER TO THIS PAGE.
CROSS OUT ANY PARTS YOU
DON'T LIKE.

WRITE A LETTER TO A
7-YEAR-OLD. CHOOSE
YOUR WORDS CAREFULLY!

Meow? Cat

SIT AT AN AIRPORT,
TRAIN STATION OR
BUS STOP. WATCH
PEOPLE COME & GO.
WHERE ARE THEY HEADED?

HAVING A ROUGH DAY?
YOU'RE PROBABLY NOT THE ONLY 1.
[📷 SHARE] A HAPPY THOUGHT
WITH #JK1PAGE, &
CHEER US ALL UP!

THIS COULD BE ANYTHING

Whenever you feel like nobody understands you, remember that it's probably because you're like really weird. Then flap your giant wings and fly off into the sunset. Land on the mountain near your cave. Breathe fire into the sky, then settle down to watch your eggs. WAIT, ARE YOU A DRAGON? That. Is. Awesome.

✳

WRITE SOMETHING IN ALL
CAPS & THEN PRESS

REPLY ALL

GIVE THIS PAGE TO A FRIEND

WRITE ABOUT A FAVORITE
MEMORY OR EXPERIENCE
YOU HAD TOGETHER.

LEAVE TINY ENCOURAGING NOTES IN DIFFERENT PUBLIC SPACES

YOU'RE DOING IT RIGHT, HONESTLY. GO YOU!

THIS MIGHT BE WHAT YOU WERE WAITING FOR.

TODAY IS THE DAY YOU FINALLY TREAT YOURSELF!

THIS FEELS LIKE THE START OF SOMETHING GOOD!

@CUTIE82_ASPX3 21h
WOW UR CRAZY OMG IS THIS
YOU IN THE VIDEO??
blt.ly/xp94a6zzQ

💬 VIEW ← REPLY ★FAV ⋯MORE

COPY THE LINE 20 TIMES,
OR UNTIL YOU LEARN YOUR LESSON!

I AM VERY RETWEETABLE

IGNORE THE HATERS
(SERIOUSLY, LEAVE THAT BLANK!)

IT'S JUST PAPER!
WRITE A NOTE ON A DOLLAR
BILL & TAPE IT TO THIS PAGE.

WHAT IS IT "WORTH" NOW?

CHECK OFF THE HOURS AS THEY GO BY:

- ☐ 12 AM
- ☐ 1 AM
- ☐ 2 AM
- ☐ 3 AM
- ☐ 4 AM
- ☐ 5 AM
- ☐ 6 AM
- ☐ 7 AM
- ☐ 8 AM
- ☐ 9 AM
- ☐ 10 AM
- ☐ 11 AM

- ☐ 12 PM
- ☐ 1 PM
- ☐ 2 PM
- ☐ 3 PM
- ☐ 4 PM
- ☐ 5 PM
- ☐ 6 PM
- ☐ 7 PM
- ☐ 8 PM
- ☐ 9 PM
- ☐ 10 PM
- ☐ 11 PM

O-K, IT'S TOMORROW!

MOST OF THE TIME
WE KNOW EXACTLY
WHAT WE NEED TO HEAR.

SO WHAT'S GOING ON?
WRITE DOWN THE FACTS,
THEN FACE THEM!

*

Have you ever gotten a professional massage? It is actually one of the best things ever. Save it for when you're really overworked....your body has earned it, promise!

DRAW A FAMILY PORTRAIT!

* YOU CAN DO IT (PROBABLY)

QUARTERLY CHECK-IN

THINK ABOUT THE LAST 3 MONTHS
& RANK YOURSELF ON THE SMILEY SCALE.

LET'S
FACE IT > ☺ GOOD 😐 FAIR ☹ POOR

GENERAL OUTLOOK ◯	PERSONAL GROWTH ◯	PHYSICAL HEALTH ◯
PLANNING AHEAD ◯	TAKING CARE ◯	EATING WELL ◯
SLEEPING HABITS ◯	BEING AWESOME ◯	MENTAL HEALTH ◯
SOME DAILY CREATIVITY ◯	SHOWING KINDNESS ◯	CALLING HOME ◯
WORKING HARD ◯	HAVING FUN ◯	BEING A FRIEND ◯
STAYING CALM ◯	TRYING HARD ◯	ENJOYING YOUR SPACE ◯
EARNING A LIVING ◯	GOING OUTDOORS ◯	THAT 1 THING ◯
FEELING CONTENT ◯	FUNNY TWEETS ◯	FIGURING IT OUT ◯

YOU CAN LIVE FOREVER,
BUT IN CASE YOU DON'T,
WHAT WILL YOUR
TOMBSTONE SAY?

LIST 5 PLACES THAT YOU WOULD RATHER BE RIGHT NOW:

1 _____

2 _____

3 _____

4 _____

5 _____

& WHY?

IT'S JUST PAPER!
WHO CARES, DUDE.

BUILD THE PERFECT SANDWICH

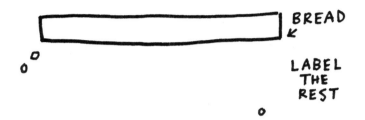

BREAD

LABEL
THE
REST

BREAD

(CRUMBS ARE A PART OF LIFE.
THE SANDWICH IS STILL PERFECT!)

DRAW YOURSELF A TROPHY
OR OTHER LARGE AWARD.

WOW, THAT'S BIG, YOU MUST
BE REALLY IMPORTANT!

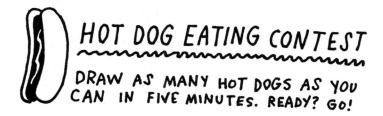

HOT DOG EATING CONTEST

DRAW AS MANY HOT DOGS AS YOU
CAN IN FIVE MINUTES. READY? GO!

GIVE THIS PAGE TO A FRIEND

WHY ARE WE FRIENDS?
WHAT MAKES US SO
AWESOME TOGETHER?
(BE CHEESY, IT'S OK!)

TAPE A PHOTO YOU
LOVE TO THIS PAGE.
YOU CAN TRIM IT IF
IT'S TOO BIG!

GO BACK TO A PAGE YOU LEFT
BLANK BEFORE & TRY AGAIN!

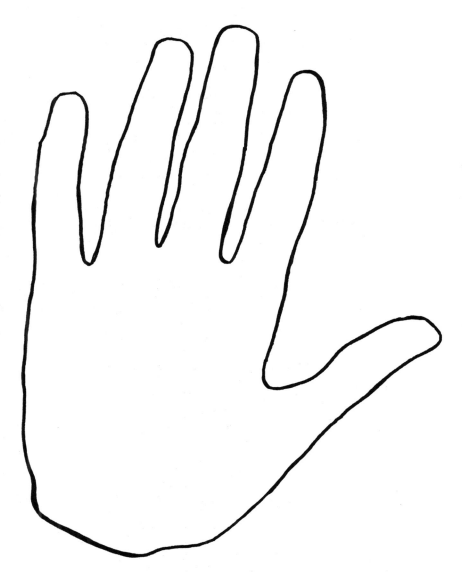

GIVE ME A HIGH-FIVE, PAT YOURSELF ON THE BACK,
WAVE TO A FRIEND, OR DRAW YOUR HAND IN MINE.

TAPE A LOOP OF THREAD
TO THIS PAGE SO YOU
 NEVER FORGET THAT
1 THING.

CLOSE YOUR EYES —
THERE IS NOTHING TO SEE HERE
& THAT IS THE POINT

1. DRAW A BEAUTIFUL FRAME
2. PUT NOTHING IN IT
3. GOOD JOB

JUST BE QUIET

YOU
SOMEWHERE ⊕ 28m

DRAW YOUR LUNCH OR
THE SKY OR WHATEVER

♥ 47 LIKES

WRITE IT HUGE

WHO'S THE BEST?
(HINT: YOU ARE)

ADMIT
IT

04893

WHAT ARE YOUR GOALS
FOR THE REST OF THE YEAR?

COPY THE LINE 20 TIMES,
OR UNTIL YOU LEARN YOUR LESSON!

I WILL DO THAT THING

GIVE THIS PAGE TO A STRANGER

IS THIS AWKWARD? DON'T WORRY, IT'S "FOR ART."
IT'S MY FAULT, I'M A VERY PUSHY JOURNAL.

DRAW A QUICK DOODLE OF THE
PERSON WHO HANDED YOU THIS.

MAKE A PLAYLIST OF AWESOME COVER SONGS:

1. WHEN SAINTS GO MACHINE "BITTERSWEET SYMPHONY"

2.

3.

4.

5.

6.

7.

8.

HOW-TO: DRAW A RECTANGLE

1. TRY TO DRAW A SQUARE
2. GOOD JOB!

FEELINGS I FELT

- ☐ SAD
- ☐ MAD
- ☐ GLAD
- ☐ NICE
- ☐ NOT NICE
- ☐ JEALOUS
- ☐ PROUD
- ☐ GRUMPY
- ☐ JOYFUL
- ☐ STRESSED

- ☐ TIRED
- ☐ BORED
- ☐ APATHETIC
- ☐ PATHETIC
- ☐ HAPPY
- ☐ FRANTIC
- ☐ SLOW
- ☐ VERY SLOW
- ☐ LOVE
- ☐ SURE

*treat yourself *to that *thing.!*

NEW MESSAGE —

TO:
CC:
BCC:

SUBJECT:

TAKE A PERSONAL DAY!
EMAIL AN EXCUSE TO YOUR BOSS.

WRITE SOMETHING #WORTHWHILE,
THEN #RUIN IT WITH #HASHTAGS.

IT'S JUST PAPER!
CUT THIS INTO STRIPS
& MAKE A CHAIN.

 If you draw patterns on this side, your paper chains will be much more exciting! Maybe something to cover up my annoying sentence. Why would I even put this here?

HOW DO I M

SEARCH

HOW DO I MAKE TOAST?
HOW DO I MAKE A JOKE?
HOW DO I MEET ALIENS?
HOW DO I MEET COOL GUYS?
HOW DO I MOVE THIS ROCK?

IF A SANDWICH WAS NAMED
AFTER YOU, WHAT WOULD IT
BE CALLED? WHAT WOULD
BE IN IT? WHY ARE YOU
RECEIVING SUCH AN HONOR?

$5.99

SPECIAL

LIST _10_ THINGS THAT MAKE YOU HAPPY:

1 _____

2 _____

3 _____

4 _____

5 _____

6 _____

7 _____

8 _____

9 _____

10 _____

* I AM JUST A BOOK, BUT
I BELIEVE IN YOU

DESCRIBE YOUR DREAM DATE

~~A 10 HOUR NAP, ALONE~~
~~FREE WIFI~~

* Why am I so tired today?

COMFORT ZONE:

FILL THE PILLOW WITH
STUFF THAT MAKES YOU
FEEL GOOD!

GIVE THIS PAGE TO A FRIEND

DRAW US IN 30 YEARS
(SHOW NO MERCY!)

TAPE A SMALL LEAF TO
THIS PAGE. <u>OMG</u> IS THAT
DISRESPECTFUL TO TREES?

FIND A WAY
TO TELL A
SECRET ON A
POSTCARD...
REMEMBER THAT
EVERYONE CAN
SEE IT!

THAT WAS AWESOME!

WHAT WAS
THAT SONG
YOU WERE
TELLING
ME ABOUT?

WHAT HAVE YOU COLLECTED?
STICKERS? CARDS? SOCK?
LIST OR DRAW BELOW!

Speaking of collecting, there are 8 glasses of water tucked away in this book. Can you find them all? *

THE ONLY THING HERE IS YOU

THINK ON
THE OUTSIDE
OF THE
SQUARE

(FAMOUS QUOTE)

DRAW SOMETHING
TERRIBLE THAT YOU
CAN'T UNDO

IT GETS LONELY SOMETIMES, BEING A BOOK... IF YOU'VE EARNED IT, TREAT US BOTH TO A NEW PEN OR PENCIL!

DRAW BLOOD

(NOT LITERALLY!)

Count from 1 to 100. Now 200. Count until the page is covered! ✳

leave a big tip!

CUSTOMER COPY

5974774

AMOUNT

PRICE

RATE

SUB

TAX

TIPS MISC

TOTAL

DATE

QU. CLASS DESC.

AUTH

REG

CLERK

SER VER

DATE

REF

CHECK NO.

SALES SLIP

IMPORTANT: RETAIN THIS COPY

4249 1738 2917 0344

ex. 11/17

PURCHASER SIGN HERE

X

GO TO A PARK.
EWW, NATURE!
DO THEY HAVE WIFI?
DRAW THE BEST TREE.

MAKE A PLAYLIST FOR CRYING:

1. THE ANTLERS
 " I DON'T WANT LOVE "

2.

3.

4.

5.

6.

7.

8.

FILL ALL OF THIS SPACE.
STARE AT IT. NOW MOVE ON.

DRAW OR WRITE "UNDERWATER"
BY MAKING EVERYTHING ALL
WOBBLY. ADD A FISH, MAYBE.

*treat yourself to *coffee or *tea!*

TRY TO START WRITING
SOMETHING BUT NOT
KNOW WHERE IT'S
HEADED OR IF IT'S EVEN
A SENTENCE, BANANA.

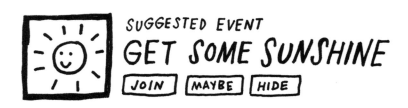

SUGGESTED EVENT

GET SOME SUNSHINE

JOIN | MAYBE | HIDE

IT'S JUST PAPER! CUT THIS PAGE INTO A CROWN.

* You might need to cut three strips and do a narrower crown if you have a bigger head! Like if you are a human being, because this is a small book, isn't it.

DECORATE YOUR SPACE WITH THESE PIN-WORTHY RIBBONS!

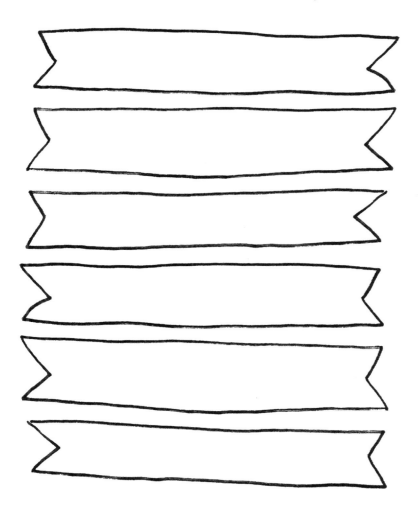

YOU DID IT! CONGRATULATIONS!
WRITE A PRESS RELEASE TO
ANNOUNCE YOUR BIG
ACCOMPLISHMENT:

LIST 8 THINGS THAT YOU ARE AFRAID OF:

1 _____

2 _____

3 _____

4 _____

5 _____

6 _____

7 _____

8 _____

* LIFE IS A FULL-TIME JOB

HOW ARE YOU FEELING TODAY?
WHAT IS THE ROOT OF THAT EMOTION?

ANONYMOUS ASKED YOU:

WOW NICE BLOG!
THIS IS MOM, BTW. LOVE YOU!

✕ ☑

GIVE THIS PAGE TO A FRIEND

WRITE DOWN A SECRET. GIVE THE
BOOK BACK. DIGEST THE INFORMATION
THEN CROSS IT OUT. NEVER SPEAK OF
THIS EVER AGAIN.

WHAT'S IN YOUR BAG?
DRAW YOUR BAG & ALL
YOUR STUFF!

TAPE AN EMPTY SUGAR
PACKET TO THIS PAGE.
NICE, DUDE, THAT LOOKS SWEET!

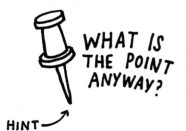

WHAT IS
THE POINT
ANYWAY?

HINT

Woah! Bet you didn't realize that this is day 250! What's been your favorite page so far? You've accomplished 249 things already, so pat yourself on the back, and get ready to keep on going. I'm with you to the end! ✶

WHAT
HAPPENED
LAST
NIGHT?

*
** *
*

ok!

IT IS O-K TO BE OPEN

SOMETIMES DULL,
SOMETIMES SHARP,
ENDLESS POTENTIAL,
BUT NOT PERMANENT
& THAT'S THE POINT.

WRITE IT HUGE

*
SHOUT! SHOUT! SHOUT!

Draw yourself a grid, then check off each box like a tiny accomplishment.
That feels so good! Look how much you've done!

(OMG, I CAN'T BELIEVE
 I PUT THAT IN A BOOK!)

MAYBE YOU SHOULD
HAVE FAITH IN SOMETHING
INTANGIBLE JUST IN CASE.

GO TO THE GROCERY STORE.
WHO DO YOU SEE? SPY ON
THE SHOPPING CARTS.
WHAT DO YOU THINK IS
FOR DINNER? WHO BUYS
THE MOST SNACKS?

MAKE A PLAYLIST
FOR TRUE LOVE:

1. LIANNE LA HAVAS
 "EVERYTHING EVERYTHING"

2.

3.

4.

5.

6.

7.

8.

What's On Your Mind?

SUMMER CHECKLIST

- ☐ POPSICLE
- ☐ BEACH DAY
- ☐ PICNIC
- ☐ ICE CREAM TRUCK
- ☐ FERRIS WHEEL
- ☐ CORN DOG
- ☐ ROAD TRIP
- ☐ FLIP-FLOPS
- ☐ SHORT HAIR
- ☐ SUN BURN
- ☐ BUG BITE
- ☐ LEMONADE
- ☐ BUTTERFLIES
- ☐ SHORT SHORTS
- ☐ STARRY NIGHTS
- ☐ SUMMER LOVIN'
- ☐ FIREWORKS
- ☐ FLY A KITE

FAVORITES

CIRCLE
ONE

RED BLUE	CHOCOLATE VANILLA	HOT COLD
DAY NIGHT	COFFEE TEA	MOM DAD *JUST KIDDING!* ←
PEN PENCIL	PANTS SHORTS	YESTERDAY TOMORROW
BOYS GIRLS	KETCHUP MUSTARD	CATS DOGS

Sometimes it may seem like there isn't 1 really good choice.
Don't forget, there's always another option. Or change the question! Or don't answer it! You're in control. *

WRITE A NOTE TO
SOMEONE YOU'VE
NEVER MET BEFORE

LAUGHTER IS THE BEST
MEDICINE, BUT YOU KNOW
WHAT ELSE IS? ACTUAL
MEDICINE. IF YOU DON'T
FEEL WELL, GO TO THE
DOCTOR! FOR NOW,
WRITE DOWN SOME
JOKES FOR THE
WAITING ROOM.

QUARTERLY CHECK-IN

THINK ABOUT THE LAST 3 MONTHS
& RANK YOURSELF ON THE SMILEY SCALE.

LET'S FACE IT ⟩ ☺ GOOD ☺ FAIR ☹ POOR

GENERAL OUTLOOK ◯	PERSONAL GROWTH ◯	PHYSICAL HEALTH ◯
PLANNING AHEAD ◯	TAKING CARE ◯	EATING WELL ◯
SLEEPING HABITS ◯	BEING AWESOME ◯	MENTAL HEALTH ◯
SOME DAILY CREATIVITY ◯	SHOWING KINDNESS ◯	CALLING HOME ◯
WORKING HARD ◯	HAVING FUN ◯	BEING A FRIEND ◯
STAYING CALM ◯	TRYING HARD ◯	ENJOYING YOUR SPACE ◯
EARNING A LIVING ◯	GOING OUTDOORS ◯	THAT 1 THING ◯
FEELING CONTENT ◯	FUNNY TWEETS ◯	FIGURING IT OUT ◯

IT'S JUST PAPER!
FOLD THIS PAGE
IN HALF.

IF YOU HAD TO WEAR THE
SAME OUTFIT EVERY DAY,
WHAT WOULD IT BE? WHAT
IS YOUR ICONIC LOOK?
DESCRIBE OR DRAW BELOW!

FAVORITE BOOKS:

THIS BOOK

(FILL IN THE SPINES!)

DRAW A NEEDLE IN THE
CENTER OF THE PAGE.
NOW DRAW A HAYSTACK.
TRY NOT TO LOSE IT!

THERE IS ALWAYS MORE
(FILL THIS PAGE WITH ASTERISKS)

* * * * * * *

HEY, TOUGH GUY!
DRAW SOME T-SHIRTS,
THEN CUT OFF THE SLEEVES.

BEACH DAY! YEEEAAAAHHH!
DRAW EVERYTHING YOU NEED:

WHO WAS YOUR CHILDHOOD
BEST FRIEND? HAS THAT
CHANGED? WHERE ARE
THEY NOW?

TAPE A STRAND OF YOUR
HAIR TO THIS PAGE.
1 DAY YOU MIGHT NOT
HAVE ANY LEFT!

∗
Remember when you wrote yourself a letter six months ago? Go back and find it!

IT'S JUST PAPER!
WRITE "CAUTION" REPEATEDLY,
THEN SHRED THE PAGE &
THROW IT TO THE WIND.

"This is my throwing page"

*

THIS IS WHAT YOU SAY IT IS

FILL THIS SPACE
WITH BAD HABITS,
THEN CUT IT OUT!

DON'T PAY TOO MUCH ATTENTION
TO OTHER PEOPLE'S CURATED
PUBLIC LIVES. #NOFILTER

WRITE THAT MESSAGE
THAT YOU JUST
CAN'T SEND

LIST 5 PEOPLE YOU USED TO KNOW & WHAT HAPPENED:

1 _____

2 _____

3 _____

4 _____

5 _____

SUGAR
WATER
ZERO DIE
CARAMEL
COLOUR C
12 oz, 355 m

WRITE A LETTER TO AN
INTERNET "FRIEND" THAT
YOU DON'T KNOW & CAN'T
REMEMBER ADDING.

SEND A PHOTO OF THIS
PAGE AS AN ICEBREAKER.

MAKE A PLAN OF ACTION TO
HANDLE YOUR TASKS THIS WEEK:

LOOK UP TODAY! LOOK
FOR BIG CRACKS, CEILING
TILES, & ORNATE DETAILS.
DRAW OR DESCRIBE YOUR
FAVORITE.

MAKE A PLAYLIST FOR SINGING IN THE SHOWER:

1. NATALIE IMBRUGLIA "TORN"

2.

3.

4.

5.

6.

7.

8.

1 thing

no thing

any thing

some thing

every thing

DATE CHECKLIST

- ☐ CHECK HAIR
- ☐ STALK ONLINE
- ☐ 8 PM
- ☐ NEW SHIRT
- ☐ 8:05
- ☐ BREATH MINT
- ☐ THEY'RE HERE!
- ☐ SWEATY PALMS
- ☐ BITE LIP
- ☐ LAUGH LOUD
- ☐ BUTTERFLIES

- ☐ ACT COY
- ☐ MUTUAL FRIEND
- ☐ SMALL TALK
- ☐ LAUGH MORE
- ☐ BIG TALK
- ☐ LET'S DANCE
- ☐ MORE DRINKS
- ☐ FIRST KISS!!
- ☐ MY PLACE?
- ☐ LET'S WAIT
- ☐ TEXT FRIEND

TELL ME ABOUT THAT
REALLY FUNNY THING
THAT HAPPENED:

WOW,
EVERYONE
LOVES YOUR
POST!

75,631 NOTES

IT'S JUST PAPER!
DRAW A BRICK WALL.
PUT IT UP, THEN TEAR IT DOWN.

If you didn't tear down your wall that is O-K too. Maybe you can let your wall down at your own pace, brick by brick.

*

TELL ME ABOUT YOUR DAY!

WHAT IS THE BEST ADVICE YOU'VE EVER RECEIVED?

WHAT WAS THE FIRST FUNERAL
YOU ATTENDED? DO YOU THINK
IT GETS EASIER? HOW DO YOU
CHERISH & HONOR A LOVED ONE?

LIST 10 THINGS THAT YOU LOVE TO DO:

1 _____

2 _____

3 _____

4 _____

5 _____

6 _____

7 _____

8 _____

9 _____

10 _____

DRAW AN ARM, THEN
COVER IT IN TATTOOS!

WE ARE ALL CONNECTED
(FILL THE PAGE WITH WIFI BARS)

BUT WHAT IS THE
Password?

Today is going to be a really good day. *

IMAGINE THE COOLEST JOB EVER, THEN DESIGN A BUSINESS CARD FOR YOURSELF!

FRONT:

BACK:

WRITE AN EMBARRASSING
STORY ABOUT YOUR BEST
FRIEND SO YOU CAN TELL IT
IN A TOAST AT THEIR WEDDING!

DRAW THE PERFECT MEAL,
THEN COVER IT IN HOT SAUCE!

SEND

UPDATE

POST

OKAY

SURE

YES?

MAYBE

FINE

HEY,

WHERE
ARE
YOU?

WHO WAS THE COOLEST KID
IN SCHOOL? WHERE ARE THEY
NOW? LOOK THEM UP
 & SEE HOW THAT GOES.

LITERALLY NOTHING

Go ahead and curse in cursive!
How can something so pretty
be so ~~fucking~~ offensive?

DRAW THE MOST USELESS
THING YOU CAN IMAGINE,
THEN LOVE IT FOREVER.

WRITE IT HUGE

DRAW YOURSELF AS A SPOON.
ARE YOU BIG OR LITTLE?

RUN AWAY FROM IT ALL!
WHERE ARE YOU GOING?
WHAT WILL YOUR NEW NAME BE?

COPY THE LINE 20 TIMES,
OR UNTIL YOU LEARN YOUR LESSON!

I WILL LOOK BACK & LAUGH

TAKE NOTE OF FASHION
TRENDS IN YOUR CITY TODAY.
WHAT DID YOU SEE THE
MOST OF? WHAT WAS UNIQUE?

MAKE A PLAYLIST FOR NOT TALKING:

1. BOARDS OF CANADA
 "ALPHA AND OMEGA"

2.

3.

4.

5.

6.

7.

8.

TRAVEL PLANS: PLAN AN ALL-AMERICAN ROAD TRIP! WHICH 8 CITIES DO YOU VISIT?

THIS WEEK

- ☐ SLEEP IN
- ☐ FEEL GREAT
- ☐ O-K, KEEP GOING

*treat *yourself to a *night **out! *

USE THIS PAGE TO PLAN THE
REMAINDER OF YOUR LIFE &
ITS WORK. JUST KIDDING!
WHO'S YOUR CELEB CRUSH?

WHAT'S THE PLAN FOR TODAY?

LOW ON CASH? CUT OUT THE
TEETH BELOW & LEAVE THEM
UNDER YOUR PILLOW!

(DRAW MORE IF YOU NEED THEM)

How is this book almost done? I feel like it's just flown by. Don't leave me! Let's cherish these last pages together.

✱

WAKE UP EARLY TOMORROW TO WATCH
THE SUN RISE. WHO ELSE IS UP?
WHEN WAS THE LAST TIME YOU WERE
UP SO EARLY?

IF SOMEONE HAD NEVER
MET YOU, BUT SEEN YOU
A FEW TIMES, HOW DO
YOU THINK THEY WOULD
DESCRIBE YOU?

LIST 8 PEOPLE YOU WOULD LOVE TO HAVE DINNER WITH:

1 _____

2 _____

3 _____

4 _____

5 _____

6 _____

7 _____

8 _____

READ ANY GOOD BOOKS LATELY?

NO, LIKE WHAT IS THAT BOOK?
YOU THINK ANOTHER BOOK IS
GOING TO TAKE CARE OF YOU
THE WAY I DO? LET ME GUESS,
IT HAS PAGE NUMBERS.

PLAN
AHEAD!

DRAW SIX WATCHES,
ONE AT A TIME.

GIVE THIS PAGE TO A FRIEND

SURPRISE ME!

SNEAK A SOUVENIR FROM
A DATE & TAPE IT HERE...
BUT DON'T BE A CREEP!

WRITE SIX SHORT STORIES OF SIX WORDS EACH:

✱ "This was hard until I finished."

SCRIBBLE
THIS ENTIRE PAGE
WITH ME

Draw a grid. What's the point of it all? I don't know, but try graphing out points and see what you get!

✳

YOU ARE O-K

THINGS ARE WHAT
YOU MAKE OF THEM...
SO MAKE SOMETHING!

NEEDS: WANTS:

*
What do you love about yourself the most?

DOUBLE-TAP

TO LIKE
THIS PAGE

1. DRAW A BICYCLE
2. DRAW A BICYCLE BUILT FOR TWO
3. DRAW A BICYCLE BUILT FOR ZERO

* REMEMBER WHAT IS IMPORTANT TO YOU.

GO TO THE MALL. BUY NOTHING.
WHAT DID YOU WANT THE MOST?

MAKE A PLAYLIST OF
THE BEST SONG EVER:

1. MARIAH CAREY
 "ALL I WANT FOR
 CHRISTMAS IS YOU"

~~2~~. NO OTHER SONGS

SLOW ⧗ DOWN

WINTER CHECKLIST

- ☐ SNOW ANGEL
- ☐ HOT COCOA
- ☐ WARM SCARF
- ☐ SPACE HEATER
- ☐ FOGGY GLASSES
- ☐ WHITE BREATH
- ☐ SNOWMAN
- ☐ COLD TOES
- ☐ ICE SKATING
- ☐ SOUP

- ☐ FIREPLACE
- ☐ CUDDLES
- ☐ SKI TRIP
- ☐ ICICLES
- ☐ SHOVEL DUTY
- ☐ IGLOO
- ☐ DIRTY SNOW
- ☐ FEBRUARY
- ☐ WET CLOTHES
- ☐ MORE SOUP

(IT'S OK, I DON'T KNOW WHAT I AM DOING EITHER)

Sometimes life is difficult and it seems like nothing is working out, but there's always tomorrow, always another chance. Seriously.

NEVER
FORGET
TO
REMEMBER

IT'S JUST PAPER!
 REMEMBER WHEN YOU TAPED
 A $5 BILL TO A PAGE?
GO FIND IT & give it away!

QUARTERLY CHECK-IN

THINK ABOUT THE LAST 3 MONTHS
& RANK YOURSELF ON THE SMILEY SCALE.

LET'S
FACE IT > 😊 GOOD 😐 FAIR ☹ POOR

GENERAL OUTLOOK ○	PERSONAL GROWTH ○	PHYSICAL HEALTH ○
PLANNING AHEAD ○	TAKING CARE ○	EATING WELL ○
SLEEPING HABITS ○	BEING AWESOME ○	MENTAL HEALTH ○
SOME DAILY CREATIVITY ○	SHOWING KINDNESS ○	CALLING HOME ○
WORKING HARD ○	HAVING FUN ○	BEING A FRIEND ○
STAYING CALM ○	TRYING HARD ○	ENJOYING YOUR SPACE ○
EARNING A LIVING ○	GOING OUTDOORS ○	THAT 1 THING ○
FEELING CONTENT ○	FUNNY TWEETS ○	FIGURING IT OUT ○

YEARBOOK TIME!
DRAW YOUR HIGH SCHOOL
SELF & GIVE YOURSELF
A SUPERLATIVE.

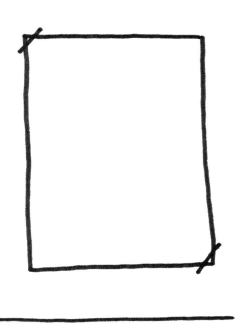

MOST LIKELY TO:

LIST 5 THINGS THAT YOU WANT TO TRY:

1 _____

2 _____

3 _____

4 _____

5 _____

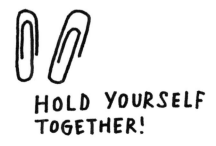

HOLD YOURSELF
TOGETHER!

YOU MADE IT!

IT'S BEEN A LONG YEAR SINCE
YOU FIRST OPENED THIS BOOK, BUT
LOOK AT US NOW. YOU'RE 1 YEAR
OLDER, AND I'M FULL OF YOUR
EXPERIENCES, GOALS AND MORE.

I'M NOT THE SAME AS I WAS. BY
DOING 1 PAGE AT A TIME WE HAVE
BOTH GROWN. SO GET A PEN &
CROSS THAT GUY'S NAME OFF OF
THE COVER. YOU DID THIS ON YOUR
OWN, & YOU'LL KEEP DOING IT.

CREATE SOMETHING, ANYTHING,
EVERY SINGLE DAY. DOCUMENT &
SAVE & ADD IT ALL UP. THIS IS
YOUR LIFE AND YOU MADE IT.

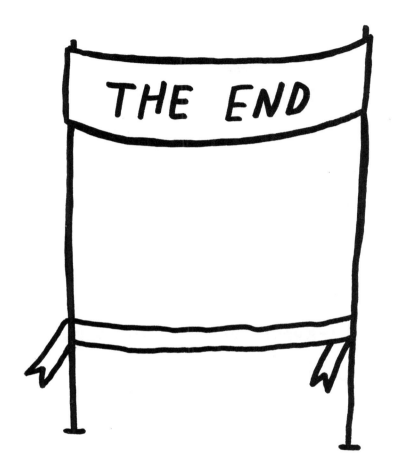

IT'S JUST PAPER!
TEAR THROUGH THE FINISH LINE.

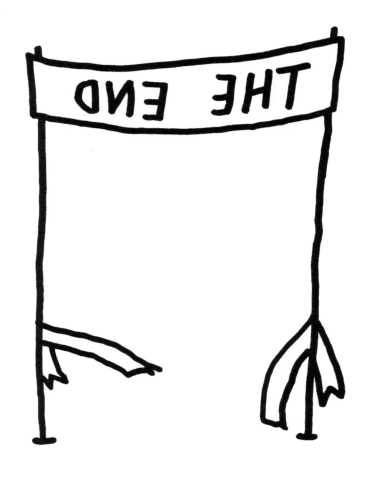

IT'S JUST PAPER!
TEAR THROUGH THE FINISH LINE.

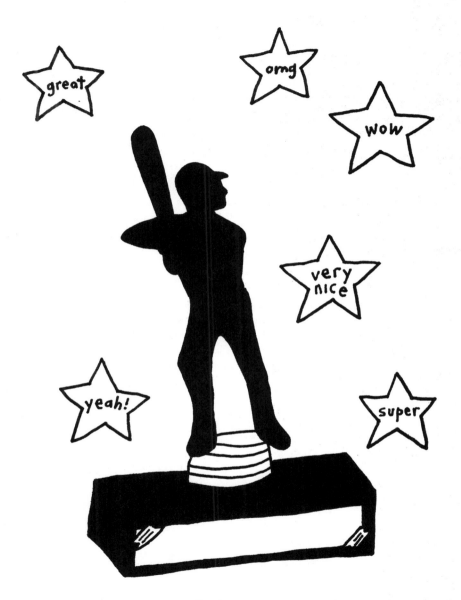

FILL IN YOUR ACCOMPLISHMENT

QUICK! BEFORE YOU GO:

WHAT WAS THE MOST
IMPORTANT THING YOU
LEARNED THIS YEAR?

LIST 5 BEST MOMENTS:

1 _____

2 _____

3 _____

4 _____

5 _____

DRAW YOURSELF
365 DAYS OLDER:

WHAT WILL YOU DO NEXT?

FILL THE SPACE WITH SOMETHING GREAT

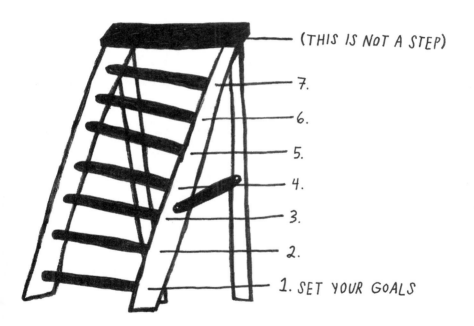

WHERE YOU'RE GOING

(THIS IS NOT A STEP)

7.

6.

5.

4.

3.

2.

1. SET YOUR GOALS

WHERE YOU ARE

1. THIS WORK IS MY OWN, BUT WOULDN'T BE POSSIBLE WITHOUT A COMMUNITY OF ARTISTS & MAKERS WHOSE LIKE-MINDED CREATIVE WORK IS BOTH INSPIRING & USEFUL.

2. THANK YOU TO EVERYONE WHO BELIEVES IN ME, EVEN WHEN I DON'T KNOW WHAT I'M DOING. I AM GRATEFUL TO ANYONE WHO HAS EVER LOVED A THING I'VE MADE, WRITTEN TO ME, OR PRESSED A HEART-SHAPED BUTTON.

3. I MADE THIS BOOK DURING A DIFFICULT YEAR. IT CAN SEEM IMPOSSIBLE TO GET THROUGH 365 OF ANYTHING, BUT THIS IS MY NOTE TO SELF. THANK YOU TO MY FRIENDS, FAMILY, & MITCHELL KUGA, WHO HAS BEEN BOTH.

4. THANK YOU TO SINGER/SONG-WRITER MICHELLE BRANCH, WHO I DO NOT KNOW PERSONALLY.

ADAM J. KURTZ IS A GRAPHIC DESIGNER, ARTIST, & SERIOUS PERSON. HE IS PRIMARILY CONCERNED WITH CREATING HONEST, ACCESSIBLE WORK, INCLUDING A RANGE OF SMALL PRODUCTS & THE SELF-PUBLISHED "UNSOLICITED ADVICE" CALENDAR SERIES. HE IS THE AUTHOR OF NO OTHER BOOKS, BUT HE'S WORKING ON THAT.

HE CURRENTLY LIVES IN NEW YORK CITY.

VISIT
ADAMJK.COM, @ADAMJK,
& JKJKJKJKJKJKJKJKJKJK.COM
(OR DON'T!)

Also available from Adam J. Kurtz

Wherever books are sold or books.adamjk.com